Laying a Watercolour Wash

FRANK HALLIDAY

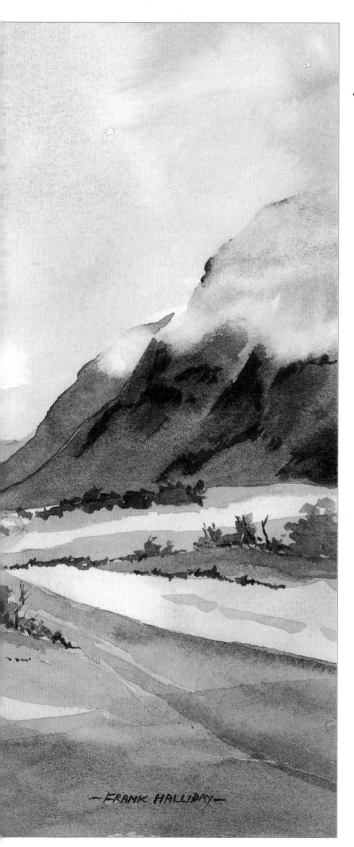

— FRANK HALLIDAY —

SEARCH PRESS

First published in Great Britain 1999

Search Press Limited
Wellwood, North Farm Road,
Tunbridge Wells, Kent TN2 3DR

Text copyright © Frank Halliday 1999

Photographs by Search Press Studios
Photographs and design copyright © Search Press Ltd. 1999

ISBN 0 85532 902 5

The Publishers and author can accept no responsibility for any consequences arising from the information, advice or instructions given in this publication.

The publishers would like to thank Winsor & Newton for supplying many of the materials used in this book.

Suppliers
If you have difficulty in obtaining any of the materials and equipment mentioned in this book, then please write to the Publishers at the address above, for a current list of stockists, including firms who operate a mail-order service. Alternatively, write to Winsor & Newton requesting a list of distributers.

Winsor & Newton, UK Marketing
Whitefriars Avenue, Harrow,
Middlesex. HA3 5RH

Colour separation by Graphics '91 Pte Ltd, Singapore
Printed in Spain by Elkar S. Coop. Bilbao 48012

To my wife Carol, my most outspoken critic and number one fan. Without her, you would not be reading this!

I would like to thank Roz Dace for asking me to write the book, and for planning it, Chantal Porter my Editor, Lotti for superb photographs, and all the other lovely people at Search Press. Thanks also to James Lee and everyone else at Winsor & Newton, Jock Clarke of Jarrolds of Norwich, and Mike Cronin, my art tutor of many years ago.

Page 1
Waiting for the Tide
300 x 400mm (12 x 16in)

Pages 2–3
The Road to the Loch
380 x 300mm (15 x 12in)

Page 5
Towards the City
510 x 355mm (20 x 14in)

Publishers' note

All the step-by-step photographs in this book feature the author, Frank Halliday, demonstrating how to paint with watercolours. No models have been used.

There is a reference to sable hair and other animal hair brushes in this book. It is the publishers' custom to recommend synthetic materials as substitutes for animal products wherever possible. There are now a large number of brushes available made from artificial fibres and they are satisfactory substitutes for those made from natural fibres.

Contents

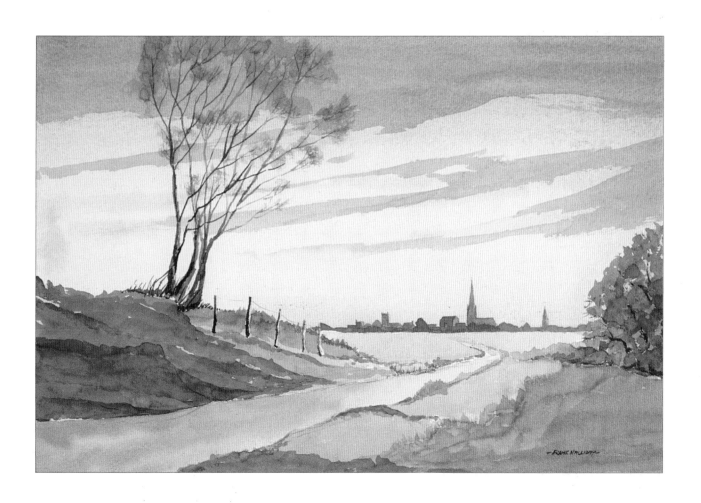

Introduction

Congratulations – you have just made the first step to discovering the joys of watercolour. Together, I hope we can share the magic as I take you on a painting journey. You will learn how to paint beautiful, luminous washes and use them to create atmosphere, tone, form and shape. Skies, landscapes and waterscapes can all be washed on to the paper, and the merging colours can be allowed to run into each other to create sunsets, mountains, distant mists, fields, rivers, seas and reflections.

I start by showing you how to experiment and play with colours, and how to paint with a limited palette. Using step-by-step demonstrations, I then illustrate how to capture perspective and atmosphere, and how to paint skies, trees, a landscape, water and a seascape. Other paintings are included to inspire you to go on and be more creative.

As a tutor, I am aware of the problems experienced by students, so I have also included many helpful hints and tips. Some of the most frequently asked questions are about painting rivers, mixing colours, preventing the paper from curling when wet colours are applied, achieving perspective and capturing atmosphere. Beginners are also often daunted by the choice of paints and brushes and find it difficult to know which to use. All these questions and more are answered in this book.

I hope you go on to use the wash techniques covered here, for many years to come. You can, of course, apply your own ideas as you develop skills and build up your expertise. Many years ago, when I was just starting to paint, if I had bought a practical book like this I would have longed to start on my first picture before even buying the materials! I am still enthusiastic about watercolours, and I enjoy the challenge of each new painting. It is a constant source of pleasure to me and I am glad that I now have the chance to share my knowledge with you. The fun starts here, so let's begin – and together we can paint some great pictures!

Clearing Mist
510 x 355mm (20 x 14in)

Subtle washes are ideal for creating atmosphere and mood. In this painting, I wanted to capture the morning sun just starting to clear away the distant mist. The sky, river and snow highlights were washed in using diluted raw sienna, then cobalt blue was washed into the top right sky and the river reflections. The distant trees were painted in using a weak wash of cobalt blue and alizarin crimson to create an impression of distance, then burnt umber was added to the same mix to introduce more warmth. These colours were added to the hedges in the middle distance, and the foreground tree was then painted in using varying mixes of French ultramarine and burnt umber. The dark shadows on the water and the reflection of the tree were painted in using a strong mix of French ultramarine and burnt umber. Finally, the figures and dog were added to suggest scale.

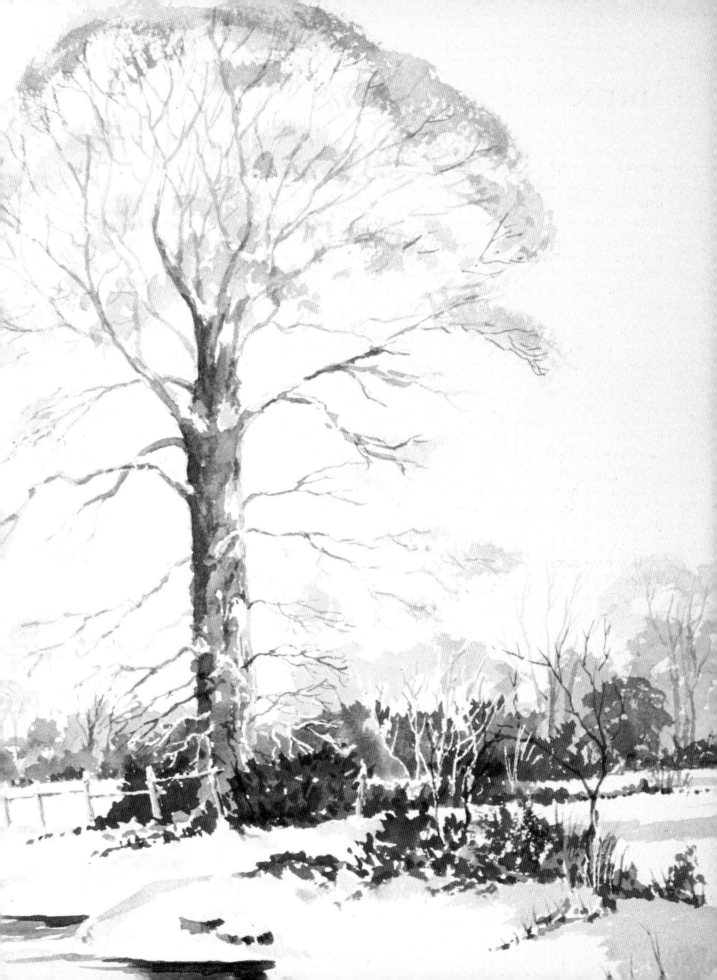

Materials

It can be bewildering when you are choosing brushes, paints and materials from the large ranges available. To help you, I have listed everything that I use. Always buy good quality materials and select a small range to start. You can always add more items later.

My palette

This is an essential piece of equipment for an artist. I use it for mixing washes, and I also lay out my choice of colours in the small compartments so that I can access them quickly. It is advisable to place them in a set order, so that you always know where your colours are when you are painting. Choose a palette with as many large compartments as you can, as these are great for mixing washes. I always prepare washes in advance so that I can use them quickly, without having to stop to mix the colours.

Listed below are the fourteen colours I use. This range is adequate for any painting situation; some I use extensively and others rarely.

If you are painting on location, you will find a portable stool or chair indispensable. This should be low enough to ensure that you are able to place your water containers and other essential items on the ground, and still be able to reach them. I find an old towel useful for levelling the ground before I put these items down.

The colours below are listed in the order that they are placed on my palette.

Cadmium lemon

Cadmium yellow

Raw sienna

Burnt sienna

Raw umber

Burnt umber

Light red

Alizarin crimson

Winsor red

Payne's gray

Cobalt blue

French ultramarine

Winsor blue (green shade)

Winsor blue (red shade)

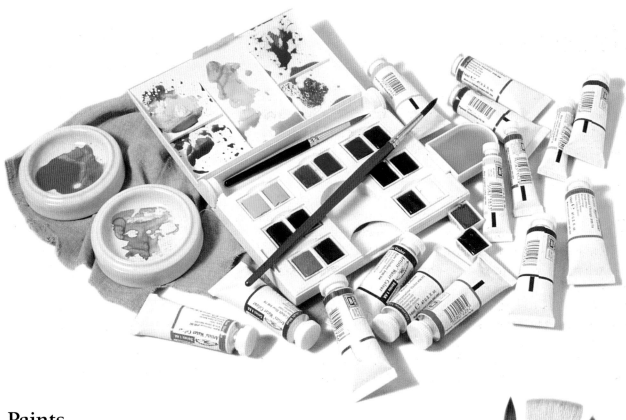

Paints

Watercolour paints are available in tubes or small pans. I prefer to use tubes as the paints are moist and they are therefore more immediate – this is particularly useful when mixing large amounts for a wash.

Brushes

There is a wide variety of brushes available and it is advisable to buy the best that you can afford. Pure sable brushes hold colour well, but you can also use blends of sable and ox-hair, or synthetic brushes.

I use rounds for my washes. They hold plenty of colour and they are available in sizes 00–24. They can also be used when painting a certain amount of detail if you look after them carefully. I prefer to use sizes 6, 12 and 16.

I also use flats. These are chisel-ended, and are available in a variety of sizes. A 50mm (2in) flat brush is ideal for washing large areas, although I often use a No. 16 round brush for this. A 10mm (⅜in) and a 13mm (½in) brush can be used to convey more detailed objects such as middle distant roofs, brickwork and fence posts. I keep a couple of these for occasional use.

Riggers are long-haired round brushes usually numbered 1–3. They are superb for fine branches on trees or bushes, rigging on ships (hence the name *rigger*) and all fine detail. I use sizes 1 and 3.

Papers

There are different types of watercolour paper – each varies in surface, thickness/weight and size. Watercolour paper is available in sheets measuring 760 x 560mm (30 x 22in), spiral bound pads or in blocks. Lighter-weight papers will need stretching (see page 12) to prevent sheets from curling when wet washes are applied. Blocks are gummed all round the edges and so individual sheets do not need stretching.

There are a choice of surfaces: Hot Pressed (H.P.) has a smooth surface; NOT, or Cold Pressed, has a slight texture; and Rough has a good texture, which is lovely for heavy washes and the dry brush technique.

Thicknesses are described as weights. A 190gsm (90lb) paper is thin and light. It needs stretching (see page 12) before being used for washes. Heavier papers are more suitable. The most widely used is 300gsm (140Ib). This, like the 190gsm (90lb) paper, will certainly need stretching if you are using a wash technique. The very heavy papers, 425–640gsm (200–300Ib), do not need stretching and will withstand any amount of rough treatment.

I usually work on a (640gsm) 300lb Rough paper because I enjoy painting on this textured surface. In fact, all the paintings in this book are painted on this weight paper.

I use sketchbooks when working outside. These are available with spiral binding, in standard book-bound form, or with sheets that are perforated.

Painting board

This is used as a base to stretch the paper on before painting. It also supports the paper once it is stretched. Your board should be approximately 50mm (2in) larger than the paper on all sides. My plywood painting board is 660 x 510 x 6mm (26 x 20 x ¼in).

Note I do not use an easel for watercolours as I have had so many disappointments when a sudden gust of wind blows everything over and – just like buttered bread – things always fall the wrong side down!

Other items

Masking tape and Gummed tape I use masking tape to tape down the heavier papers. When the painting is finished, this can be peeled off to reveal an attractive white border. Gummed tape is used when stretching lighter-weight papers on a board.

Masking fluid Fine lines of masking fluid can be applied with a mapping pen or old brush to create highlights. If you use a brush, it should be cleaned immediately after use, before the fluid hardens.

Water containers I use two old glass jars, one for rinsing brushes and the other for creating washes.

Pencil I use a 2B or 4B when drawing on watercolour paper. Soft pencils are ideal as they will not damage the delicate surface.

Putty eraser This is used to erase pencil lines. It will not damage the paper surface.

Hairdryer A hairdryer is useful for speeding up the drying time of washes.

Craft knife This is useful for sharpening pencils, and cutting masking tape or gummed tape.

Absorbent paper This has many uses, including mopping up, drying brushes and cleaning palettes.

Clips These can be used instead of masking tape to attach heavy-weight paper to boards.

Easels I tend to work with my painting board balanced on my lap, so that I have the freedom to move my work around. However, you may find it easier to work on a sketching easel.

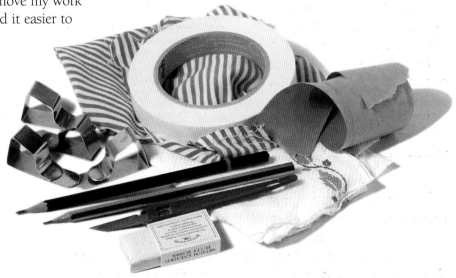

Basic techniques

This section shows you how to stretch a light-weight paper. It also introduces you to the three basic washes – flat, graded and variegated.

Stretching paper

Before you can begin to paint, you need to decide which paper you want to work on. I like using the heavy-weight papers – more than 425gsm (200lb) – which do not require stretching. If you choose a light-weight paper (see page 10), it will require stretching to prevent it from distorting when a wet wash is applied. Although this may sound complicated, the technique is not difficult, and it is essential if you want to create even washes. If you are a prolific artist, it is a good idea to stretch several pieces of paper at a time on extra pieces of board!

Note *It is advisable to stretch paper twenty-four hours before you need it, to allow time for it to dry completely. Alternatively, use a hairdryer to speed up drying time.*

1. Immerse the paper in a bowl of cold water for approximately three minutes.

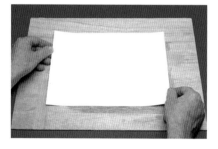

2. Remove the paper carefully. Allow excess water to drain off, then place it centrally on a board.

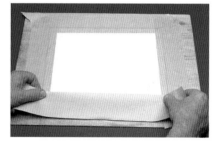

3. Tear four strips of gummed paper to fit around the edges of the paper. Wet the strips and use them to secure the paper to the board – place each strip approximately 20mm (¾in) over the edge of the paper.

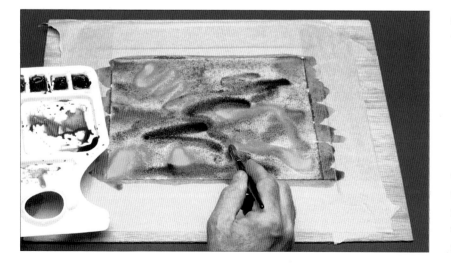

4. Allow the paper to dry keeping the board flat. You are now ready to paint, and however wet your washes are, the paper should remain taut!

Laying washes

Washes are simple and extremely effective. They can be used to create different effects – from soft skies and misty landscapes, to dense foliage and dramatic seas. Depending on the paper you use, you may need to wet the paper before you lay the wash – this will ensure that the wash is even. When painting washes, it is advisable to practice the technique first.

Flat washes are best laid in on dry paper, but they can also be worked on a wet surface. The varying degrees of wetness on the paper will effect the evenness of the wash.

Graded washes are ideal for creating the effect of distance in a landscape, for example. If you use a strong wash at the top, and weaken it down gradually as you come towards the horizon, you will create a three-dimensional effect.

Variegated washes are created using two or more colours. The different colours will fuse into each other where they meet on the paper to create wonderful effects. If you are really pleased with a particular variegated wash, make a note of the colours used so you can reproduce it again in the future.

Note It is advisable to choose a large brush when working a wash, as this will hold the most liquid, distribute the colour evenly, and ensure that the wash remains fluid.

Use a scrap piece of paper, similar to the one you are going to paint on, to test the suitability and strength of colour.

For all washes, it is best to work on a sloping board. Mix sufficient colour in advance, to cover your paper – this is important as it is impossible to recreate a mix exactly if you run out.

Flat wash

1. Load a No. 12 round brush with diluted colour. Lay in an even stroke along the top of the paper. While still wet, slightly overlap a second stroke over the first. Continue until you have completed the wash.

2. When you get to the end of the wash, dry the brush on absorbent paper, then use it to soak up excess paint.

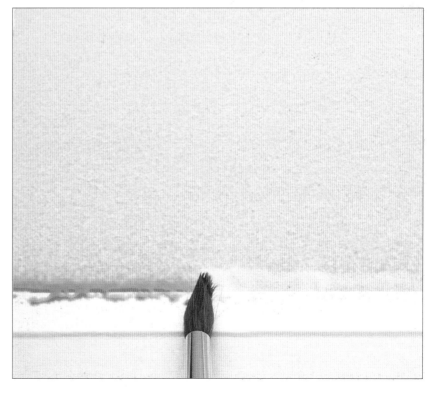

Graded wash

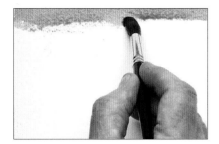

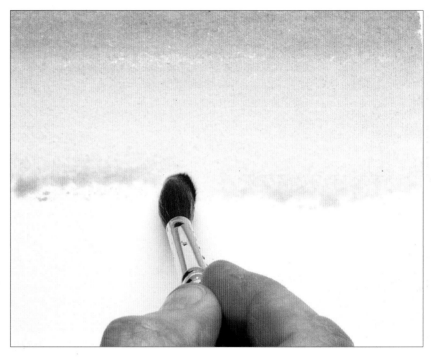

1. Use a No. 12 round brush to lay in several strokes of colour along the top of the paper.

2. Gradually add water to the colour to weaken it. Continue to lay in strokes, adding water as you go, to complete the wash.

Variegated wash

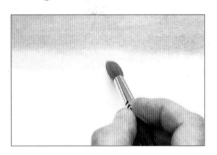

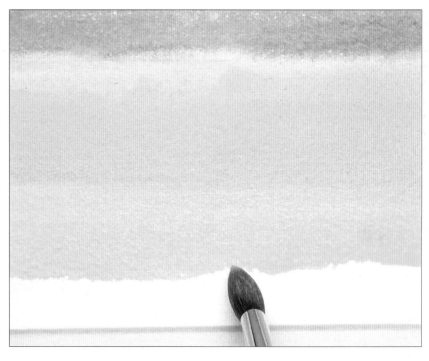

1. Lay in a few strokes of your first colour along the top of the paper, then lay in a stroke of the second colour.

2. Continue working several strokes of the second colour, then introduce a third colour.

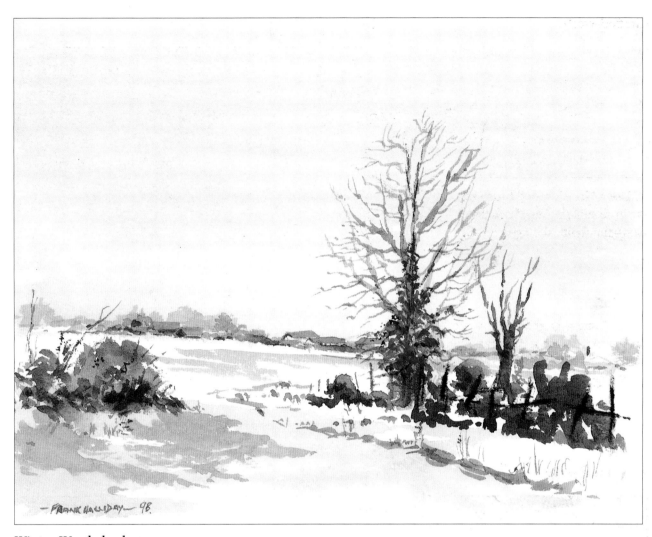

Winter Wonderland

250 x 200mm (10 x 8in)

This little study was completed as a demonstration for some of my students. As a result, it is very loose. The main feature is the use of the graded wash for the sky; this sets the colour theme throughout the picture. The large tree links the foreground with the sky and is balanced by the shrubs on the left. Shadows are used to indicate the direction of light. Beyond the open ground, I have used subdued tones to suggest distant trees and buildings.

Composition

Composition is an important aspect of any painting. It is essential that you think about all the elements in your picture before you start to paint. Ask yourself what attracts you to the view you have chosen. Pick out the most important features and emphasise those. Mentally divide your picture into thirds and place the main point of interest where the thirds intersect. This will help you when trying to decide upon the best composition. Remember that you are the one who decides what to include in a painting. If something is in the wrong place and you feel it would improve the composition if it were moved, then do so. Likewise, if you do not like something in the scene, simply leave it out!

> **Note** *Never place the horizon exactly halfway up the paper – it splits the painting in two.*
>
> *If the sky is the dominant part of your picture, place the horizon approximately one third up from the bottom of the paper. Conversely, if the sky is insignificant, the horizon should be one third down from the top.*

Correct positioning

The paintings on these pages show how a picture can be made more interesting by thinking about the composition carefully and positioning yourself accordingly. It is amazing how different a picture can look if you simply move a few metres. You should also think about shadows when you are painting – as these can add enormously to the success of a picture.

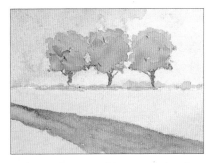

Before *The centred horizon splits this painting in two. In the lower half, the track takes the eye out of the picture. In the top half, the three almost identical trees are placed in a straight line, so there is no sense of depth. When the picture was painted, the sun was directly behind me, which generated a flat light and very little visible shadow.*

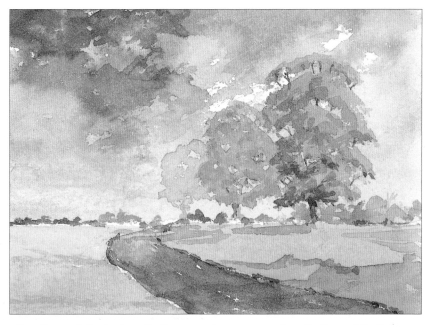

After *I moved the horizon further down the paper, and made the track lead the eye into the picture. The trees are now spaced apart and fade away into the distance, creating the illusion of depth. The light is now coming from the right, creating shadows which can be used to good effect.*

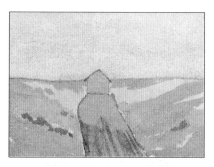

Before *This picture was painted with the sun directly behind me. I sited myself 'square on' to the building, with the horizon cutting the landscape in half.*

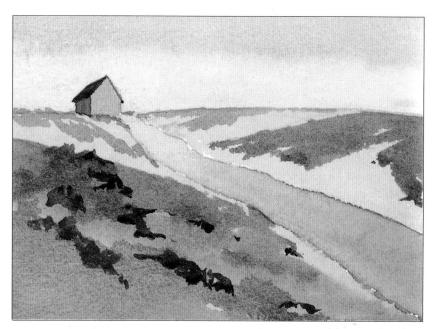

After *I moved down the hill so that the building was against the sky and above the horizon line, and the sun was to the right, creating dark shadows on the contours of the hills. Two sides of the building can now be seen which make it appear more solid. The track still leads the eye to the building, but at a more intriguing angle.*

Before *I chose a poor place to paint this picture. The trees are too similar in size; the road takes the eye out of the picture; the church looks two-dimensional; the mountains are without form; the horizon cuts the painting in half and finally, the sun is coming from behind, so there are no interesting shadows.*

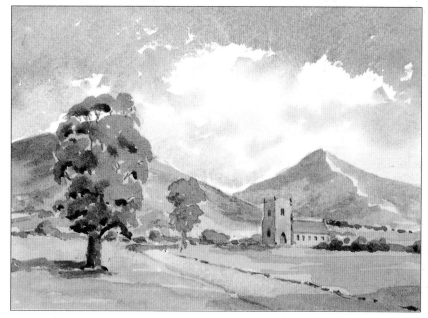

After *I have moved to the left and the sunlight is now coming from my right. This makes the church three-dimensional and the nearer tree more dominant. The mountains are more integrated into the landscape and the light now captures their contours. The road still takes the viewer through the two trees but it now leads the eye beyond the church.*

Perspective

It is impossible to cover every aspect of perspective in this short book. However, perspective is important, and it is essential that you think about it when painting. You can be an expert at washes, but if the perspective is wrong, your picture will not work.

There are two types of perspective: linear and aerial. Linear perspective is created with lines and contours, aerial perspective is created with colour.

Linear perspective

Linear perspective is the effect created when lines converge to a point or points in the distance, known as the vanishing point.

One-point

One-point perspective has just one vanishing point. If you were to lay a row of flagstones (as in figure 1) in a straight line in front of you, parallel to the horizon, they would appear to converge. The effect would be the same if you stood looking down a straight road or track.

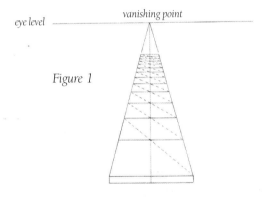

Figure 1 A helpful way to space the flagstones accurately is to draw a vertical line from the centre of the first flagstone up to the horizon (eye level). This is the vanishing point. Draw in a diagonal dotted line from one corner, through the vertical line and up to the edge vanishing line. Draw in another true horizontal from this point – this represents the back of the second flagstone. Repeat for each subsequent flagstone. Notice how they get narrower and closer together the further they go away from you.

Two-point

Two-point perspective has two vanishing points. It is used when viewing a building from an angle, for example. The nearest corner is the longest height and if you follow the line of the right-hand side wall, you will see that it goes down to meet your eye level. This is the first vanishing point. The left-hand side wall follows the same rules and again will intersect with eye level at the second vanishing point.

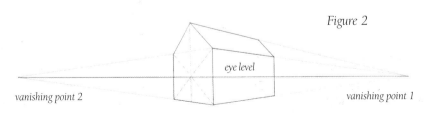

Figure 2 This basic building has the eye level line through the centre. The roof lines all merge on the same vanishing point. At ground level, the lines merge at the same point. As the building is cube-shaped, the same applies to the other side. To find the apex of the roof, lightly draw in a cross as indicated. This will show you the centre line of the end of the building.

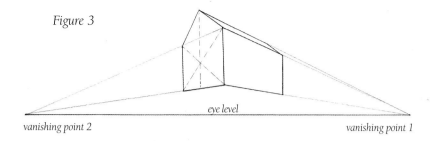

Figure 3

eye level

vanishing point 2 *vanishing point 1*

Figure 3 *If you are looking up at a building, all the lines go down towards eye level. The apex is found in exactly the same way as in Figure 2.*

Figure 4 *When you are looking down on your subject the same rules apply. Here, I have drawn the roof just above eye level. If you look closely you can just see the roof line going down to the vanishing point. When a building is above or below the eye level, a third vanishing point comes into play. For example, if you stand close to a tall office block, the sides appear to converge at the top.*

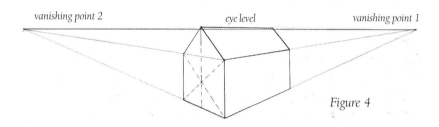

vanishing point 2 *eye level* *vanishing point 1*

Figure 4

Aerial perspective

Aerial perspective, or depth, can be achieved by painting paler values in the distance and stronger values in the foreground. Cooler colours (blues, greens and purples) also have the effect of pushing something into the distance. Introduce blues into distant trees, hills or mountains, and they will immediately sink away from you. If you use warm colours (reds, oranges or yellows) you will bring the object closer to you. If you are trying to convey aerial perspective in one colour, you can create this by using different strengths of wash.

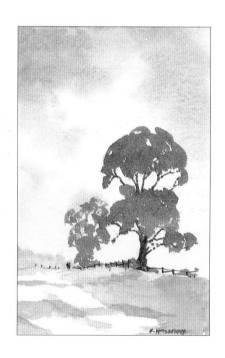

In this simple sketch, the distant trees are suggested with pale colours. The tree in the distance, which the two figures are standing by, has been painted in a blue shade. The foreground tree is painted in stronger, darker tones. I have also included linear perspective in this painting. In reality, the two large trees are probably about the same size.

Using a limited palette

Every time I pick up a book which shows how to mix colours, I switch off! I want you to enjoy colour mixing, so I have selected a series of small pictures to demonstrate how simple it can be. The colours used are illustrated alongside each painting.

Painting with two colours

You do not need many colours to create good paintings. In fact, you can create a wonderful variety of tones and shades with just two colours, as the pictures on these pages show.

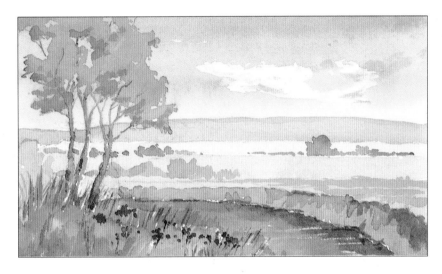

Cadmium yellow *Winsor blue (green shade)*

This combination of colours is excellent for creating mature summer grasses, leaves and trees. You can introduce burnt umber to these colours to provide an endless variation of darker shades for areas in shadow.

Cadmium lemon *Winsor blue (green shade)*

This mix of colours is ideal for the fresh greens of spring grasses and leaves. This landscape was painted using washes of the two colours shown here. The blue sky was laid in first, then a yellow and blue mix was washed on to wet paper. When dry, darker areas of the landscape and the details were painted in carefully.

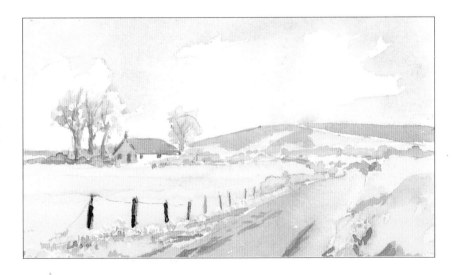

> **Note** *There are many possibilities for colour mixing. These pages give just a few combinations. You should try experimenting with colours yourself – try light red and burnt umber for brickwork, raw umber and French ultramarine for stonework and light red or burnt sienna for roof tiles.*

Raw sienna

*Winsor blue
(green shade)*

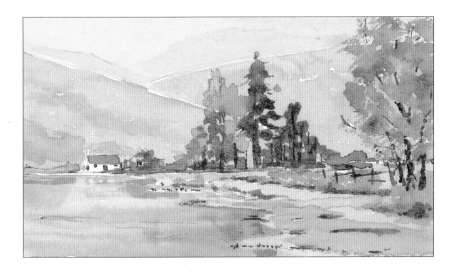

These two colours are wonderful for creating end of season grasses and foliage. A green wash was laid in first, then a darker green was laid over to indicate foliage and leaves. The dark roof on the building was painted with a nearly neat blue.

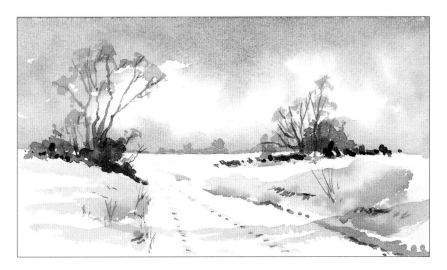

Burnt umber

French ultramarine

These two colours are perfect for creating the lovely greys and delicate browns seen in winter landscapes. They are also useful for painting branches and tree trunks, soft misty pictures and cloudy skies. French ultramarine will give a grainy sky. Add a little burnt umber as shown here, to create a range of lovely greys, or alizarin crimson for a more delicate tone.

*Winsor blue
(green shade)*

Raw umber

Try these colours for those terrific greens which appear in the crashing surf when the sea crashes against rocks. I cheated a little for the dark sides of these rocks by introducing a touch of alizarin crimson. I call it artistic licence!

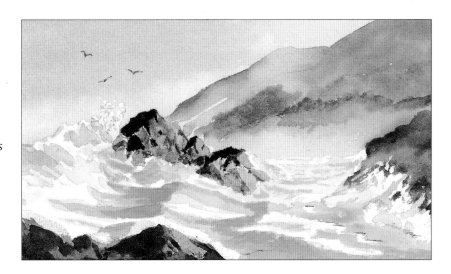

Painting with three colours

On these pages I have used a limited palette of three colours. It is worthwhile experimenting with the paints, using the pictures as a guide. Remember that it is only with practise that you will develop your skills and learn about the beauty of watercolours.

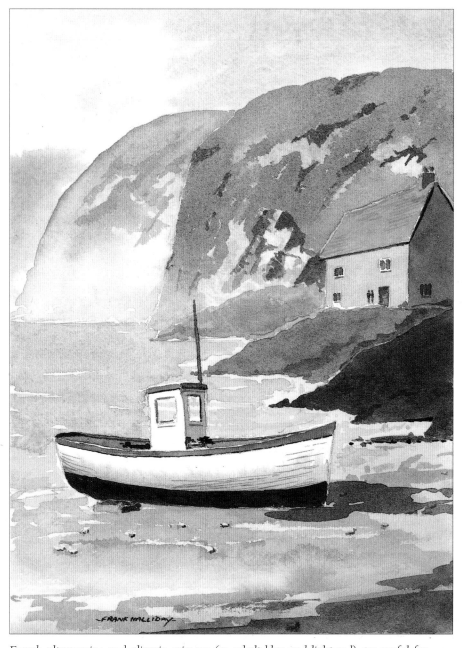

Alizarin crimson

Burnt umber

French ultramarine

French ultramarine and alizarin crimson (or cobalt blue and light red) are useful for painting in distant hills, trees and buildings. This study is of a small fishing village. The cliffs have been loosely suggested with French ultramarine, burnt umber and alizarin crimson – increasing in strength as the cliffs get closer.

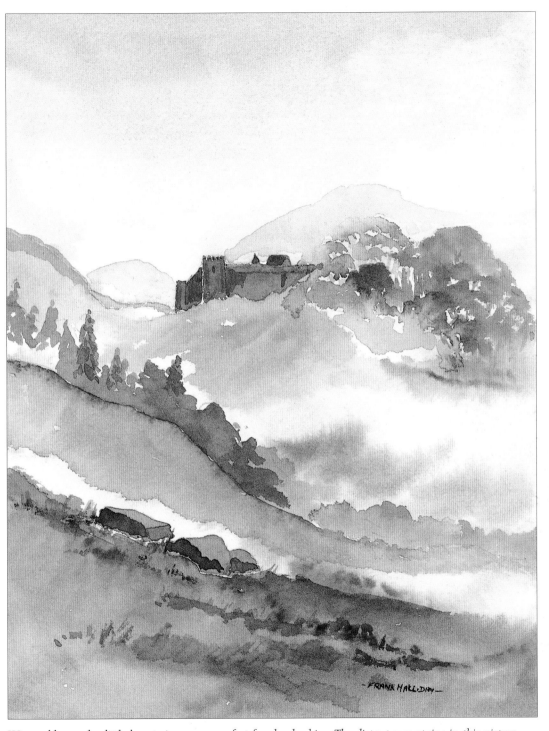

Burnt sienna

Raw sienna

*Winsor blue
(red shade)*

Winsor blue and a little burnt sienna are perfect for cloudy skies. The distant mountains in this picture used the same mix painted on top when dry. The hillsides were covered in bracken – burnt sienna was ideal for this. I wet the paper first to soften the wash and so give the impression of mist. The trees were put in very loosely and the only detail is the top of the castle battlements and the foreground rocks.

Misty Headland

Mist is quite easy to depict using washes. In this demonstration I wanted to use a variation of the graded wash on page 14 to create an actual picture. I am using raw umber for the wash, with a little Payne's gray introduced into the top of the sky. In fact, the entire picture is painted with just these two colours. Limiting the palette in this way helps to unify the painting, and it is the perfect way to express a soft, simple landscape such as this one.

1. Use a 4B pencil to draw the outlines of the headland. Sketch lightly, to avoid having to erase pencil marks later.

2. Lay a flat wash of diluted raw umber over the entire surface.

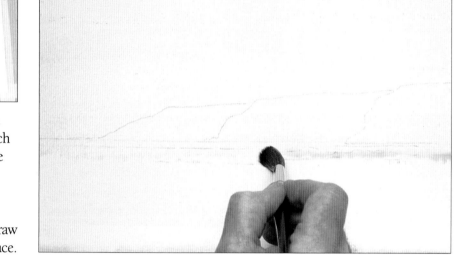

3. Introduce some Payne's gray into the top of the sky, while the first wash is still wet.

4. Pick out certain areas on the shore with Payne's gray. Leave to dry.

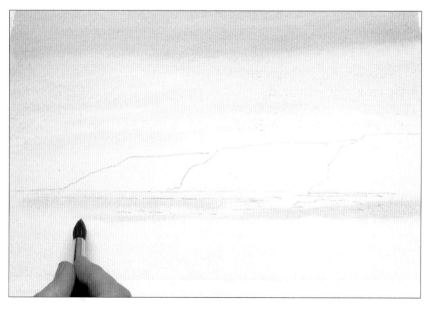

5. Wet the paper along the bottom and right-hand side of the headland on the left, then lay in a wash of Payne's gray and raw umber. Lay in the second headland using a stronger wash.

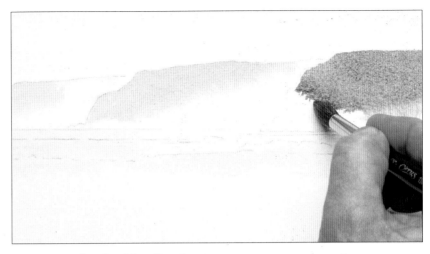

6. Paint in the third headland using an even stronger wash.

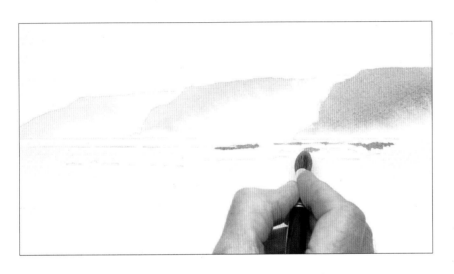

7. Strengthen the wash even more, then paint in the rocks on the foreshore.

8. Add a broader strong wash in some areas and leave to dry. Finally, if any pencil lines are still visible, remove them using a soft putty eraser.

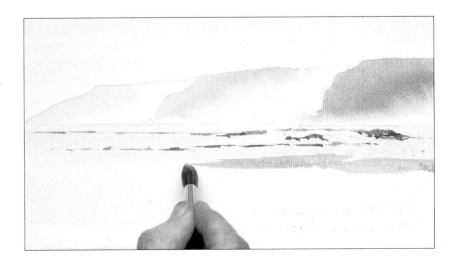

25

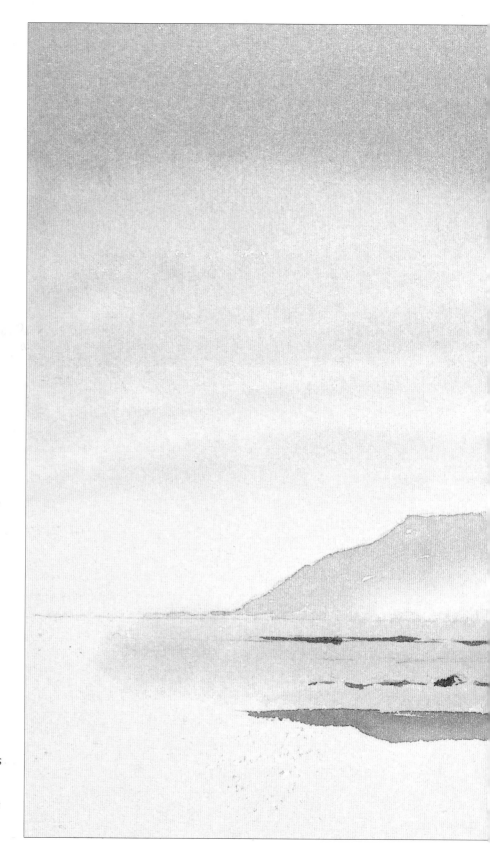

The finished painting
300 x 400mm (12 x 16in)

This painting shows the harmonious effect that can be achieved when restricting your colours and using very diluted washes. The atmosphere is conveyed with an economy of brushstrokes.

26

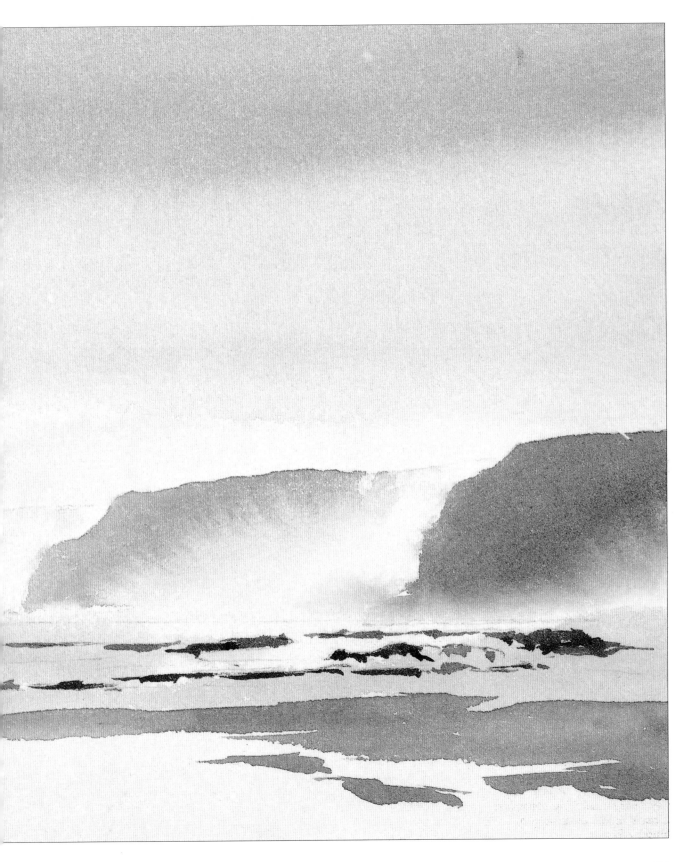

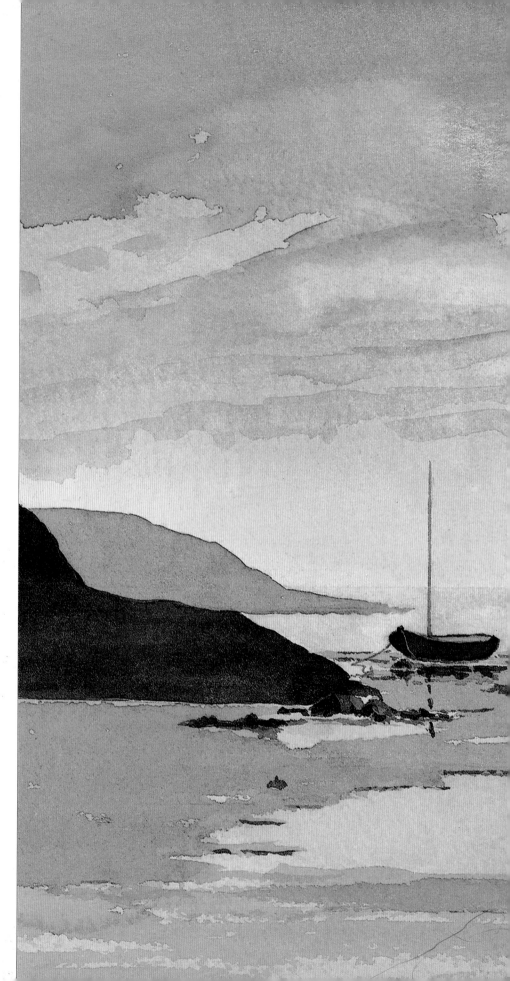

Last Light

350 x 270mm (13¾ x 10½in)

Sunsets can be painted without using gaudy colours – in fact, I think they look much more effective in subdued tones.

For this picture, I sketched out the basic shapes of the headlands, then wet the paper above the horizon line. I turned the picture upside down and, starting at the horizon, washed cadmium yellow with a touch of Winsor red right across the picture for about one third of the sky area. I then introduced Winsor red while the paper was still wet and finally Payne's gray. A little of the Payne's gray was dropped into the wet sky to give the effect of wispy clouds. When dry, the picture was turned the correct way up and the same technique and colours were repeated to paint in the sea and shore. When dry, darker tones were painted over the top of the wash to indicate the headlands and the boat. The distant headlands have less tone in them because they are nearer the light source. I added more Payne's gray to the rocks and boat which are in the middle distance.

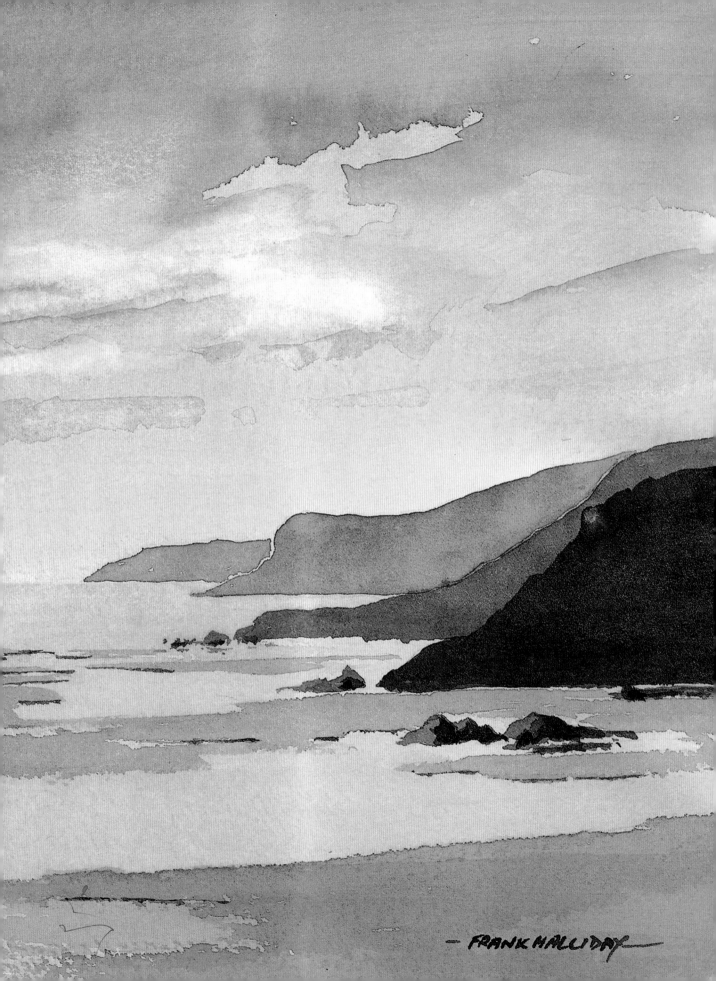

FRANK HALLIDAY

Painting landscapes

Many years ago, landscapes were considered to be simply backgrounds for people or objects. Thankfully, landscape painting is now a subject in itself, and it provides an ideal opportunity for using watercolour washes to their best effect.

When painting landscapes, remember that, as the seasons change, so will your pictures. The same scene often looks totally different in winter and summer, spring and autumn.

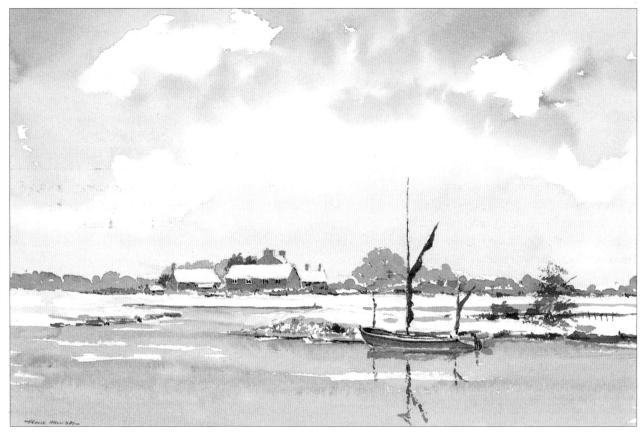

No Sailing Today
350 x 300mm (14 x 12in)

This is a quiet study in delicate shades of grey. I have used French ultramarine, burnt umber and alizarin crimson with plenty of water to make the washes more delicate. The alizarin crimson gives the painting a soft warm glow.

Skies

I cannot stress enough the importance of skies. The whole mood and ambience of a landscape is usually set by colours in the sky. The variety of cloud formations and colours are endless. Watch changing weather conditions carefully – note the difference between the strong, dark clouds of an impending storm when the immediate countryside is bathed in bright sunlight, and the calm blues of a sunlit sky. When painting on location, I recommend that you do plenty of quick watercolour sketches to capture these effects.

> **Note** *Keep your sky calm and subordinate if there is plenty happening in the rest of your painting. Alternatively, if you see a magnificent sky full of interest, ensure that the rest of your picture is simply stated to avoid lots of elements competing for attention.*

Morning sky

1. Use a No. 12 round brush to apply a variegated wash (see page 14). Begin with Payne's gray, then slowly wash in raw sienna. Leave to dry.

2. Paint in the upper clouds using a strong wash of Payne's gray.

3. Use a slightly weaker wash of Payne's gray to paint in the smaller, lower clouds.

Evening sky

1. Pencil in a sun. Use an old brush to apply masking fluid to the circle.

2. Use a No. 12 round brush to apply a variegated wash. Use French ultramarine and light red, blending into Winsor red then raw sienna. Leave to dry.

3. Rub away the masking fluid with your finger and erase the pencil lines. Introduce some dark clouds using French ultramarine with light red. Add streaks of Winsor red and raw sienna across the sun.

31

Sun and clouds

1. Wet the centre of the paper. Drop in a wash of raw sienna.

2. Wash French ultramarine mixed with a touch of burnt umber into the sky, weakening it slightly towards the lower sky.

3. Add a little light red to the French ultramarine and raw umber mix; use this to paint in the clouds. Gently roll the brush over the surface of the paper to get a subtle effect.

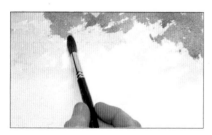

4. Mix a wash of French ultramarine with touches of light red and burnt umber, and roll in darker clouds.

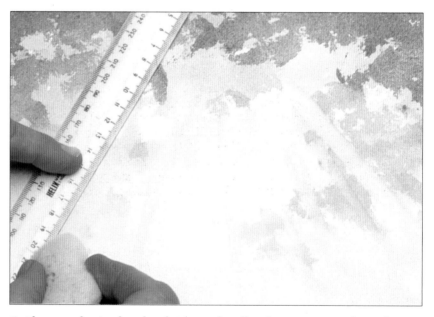

6. Place a ruler in the cloud area and pull a damp sponge along the edge. Keep the top of the ruler in the same place, but move the bottom out to create rays of sunshine.

5. Use a weaker wash; roll in some lighter clouds towards the centre of the painting.

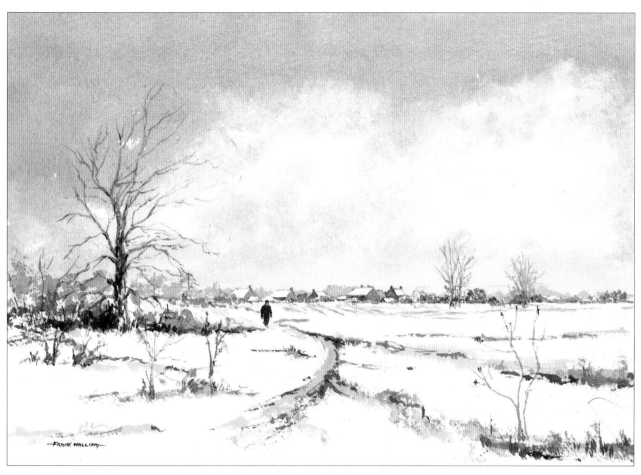

Nearly Home

250 x 350mm (10 x 14 in)

This sky was washed in and graded to give recession. Whilst the wash was still wet, some of the colour was lifted out with a tissue to create the cloud formation. The picture is composed to take the viewer straight down the path, past the tree on the left and the advancing figure (these are painted quite strongly to bring them forward), and then on to the houses. The rest of the picture is more subdued and subordinate. The brief appearance of the sun from the left allowed me to indicate the shadow of the foreground tree and the path – again helping to take the eye into the picture. As you can see, this picture was painted very loosely and quickly (in about half an hour in fact) as it was such a cold day!

Trees

There are many different types of tree, and washes can be used to great effect to paint all of them. Remember that you can create the impression of a tree or its foliage without painting every leaf in detail.

This demonstration is worked over a sky made from a graded wash of Winsor blue (red shade). I mixed a little cadmium yellow to the wash to paint in the grass.

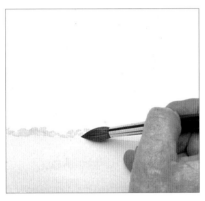

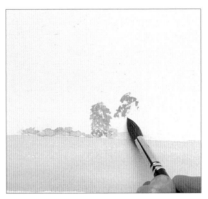

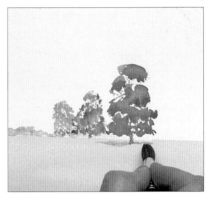

1. Mix French ultramarine with alizarin crimson. Use this on the side of a No. 12 round brush to suggest distant trees.

2. Mix French ultramarine with a little raw umber. Use the tip of the brush to add a tree to the middle distance. Add a touch of cadmium yellow and paint in another tree next to the first one.

3. Add more cadmium yellow to the previous mix and paint a big tree in the foreground. Add French ultramarine to darken the colour and then add shadows to the foliage. Use this same colour and a No. 1 rigger brush to paint in the trunk. Use Payne's gray and French ultramarine to paint in the shadow on the grass.

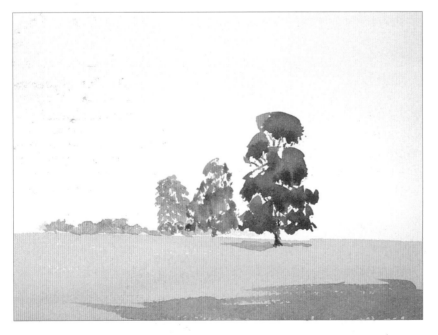

The finished painting
165 x 255mm (6½ x 10in)

Trees can be suggested using a minimum of colours and brushstrokes. This picture is a good example of how aerial and linear perspective can be used to create depth (see page 19). The dark shadow in the foreground pulls the eye into the picture.

General foliage

Trees, bushes, shrubs and all other types of greenery can all be suggested using washes. Here, I use the wet-into-wet technique to create a mass of soft green foliage.

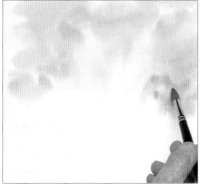

1. Apply a flat wash of raw sienna using a No. 12 round brush. Mix up various strengths of green washes using Winsor blue (green shade) with cadmium yellow, and Payne's gray with cadmium lemon. Drop these colours on to the wet wash to create the impression of foliage.

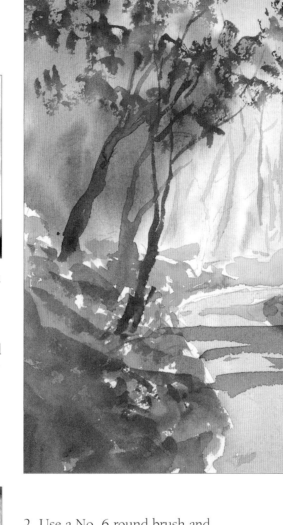

2. Use a No. 6 round brush and a weak mix of Winsor blue (green shade) with a touch of burnt sienna to paint in the distant tree trunks.

3. Paint the path using the same wash as in step 2. Use a No. 12 brush to add the foreground tree trunks and foliage in stronger mixes of the burnt sienna and Winsor blue (green shade).

The finished painting
255 x 345mm (10 x 13½in)

Foliage can be suggested quite simply, without being painted in great detail. Here, the strength of tones is gradually increased towards the foreground to give a sense of depth (aerial perspective).

Early Morning

I have used a limited palette for this project to help harmonize the picture. The secret of painting these soft moody scenes is to wet the paper before you start to paint; have your colours mixed ready; work quickly; and paint in as much as you can whilst the paper is still slightly damp. Do not work on a wash that is over-saturated with water, as any colour you introduce on top will be dramatically weakened.

What you need

Raw sienna, French ultramarine, alizarin crimson, burnt umber

640gsm (300lb) Rough watercolour paper

No. 12 round brush

No. 6 round brush

No. 1 rigger brush

Old paintbrush

Masking fluid

Absorbent paper

4B pencil

1. Sketch in the main outlines with a 4B pencil, then mask out the sun (see page 31) and selected tree trunks using an old brush.

3. Form a piece of absorbent paper into a point and, while the wash is still wet, lift a little colour from around the sun.

2. Wet the paper. Use a No. 12 round brush to drop in a raw sienna wash over the top part of the sky. Introduce a grey wash of French ultramarine with a little alizarin crimson and burnt umber. Lay in the puddles in the foreground using the same wash.

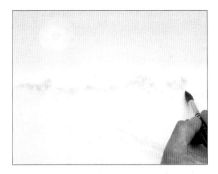

4. Use the same wash as in step 2 to paint in the trees in the far distance.

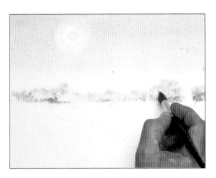

5. Blend raw sienna, burnt sienna, and a mix of burnt umber and French ultramarine into and beneath the distant grey trees.

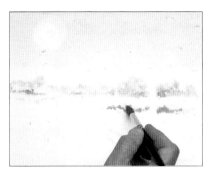

6. Use the same colours, but in stronger tones, to paint in the shrubs in the middle distance.

7. Gently remove the masking fluid by rubbing it with your finger.

8. Use a No. 1 rigger brush with various mixes of the colours already used to suggest distant trees.

9. Add darker details to the trunks of the silver birch trees, then add the branches.

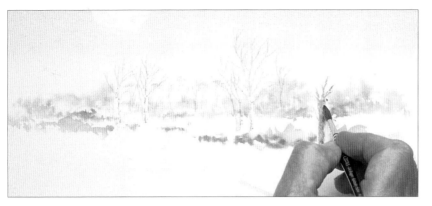

11. Use a No. 1 rigger brush and French ultramarine to paint in the further branches.

10. Lightly wet the foreground tree trunk. Use a No. 6 round brush and a No. 1 rigger brush to drop in French ultramarine and burnt umber. Do not paint the base of the trunk, as it is bathed in mist.

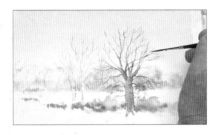

12. Gradually introduce deeper, warmer tones of burnt umber to paint the branches in the middle distance, then the darker foreground ones.

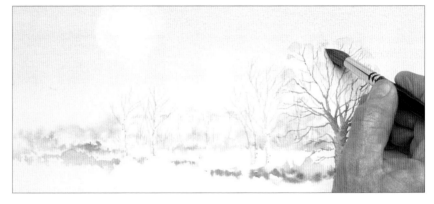

13. Suggest fine twigs at the top of the tree using a No. 12 round brush and French ultramarine mixed with burnt umber. Use weaker washes on the tops of the other trees.

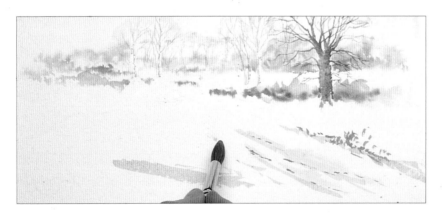

14. Use the same colours but mixed in different proportions to indicate twigs and grass in the foreground, and to suggest a path.

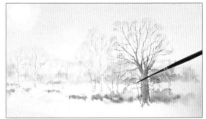

15. Link the foreground to the middle distance by painting in a few tiny trees. Work with a No. 1 rigger brush and the same colours as used in the previous few steps.

38

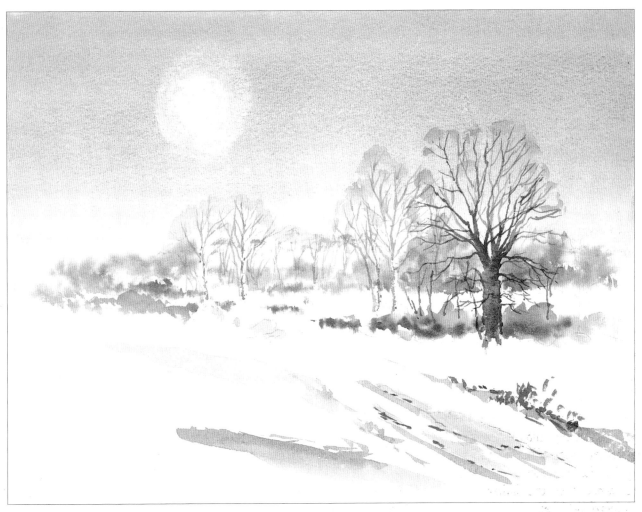

The finished painting

350 x 300mm (14 x 12in)

There are very few detailed brushstrokes in this project which helps to achieve the soft effect.

Painting water

Water is not difficult to paint using the wash techniques I have shown so far, but it does require a little practice. Next time you are near water, take a little time to study it and try to do some quick sketches.

Types of water

Here, I cover different types of water – from still puddles to cascading rivers and crashing seas.

Puddles *Water was brushed over the whole surface, then Winsor blue (red shade) was washed into the sky and puddles. While the paper was still wet, raw sienna was used to create areas of sunlight in the sky and foreground reflections. Burnt umber and Winsor blue (red shade) were then washed into the sky to create dark clouds – these, again, were reflected in the puddles. The foreground path and foliage were painted with Winsor blue (red shade) and raw sienna while the paper was still wet. The trees were painted with mixes of Winsor blue (red shade), burnt umber and alizarin crimson, and the reflections were laid in across the puddles. Finally, the bush and foreground areas were painted using stronger tones of green.*

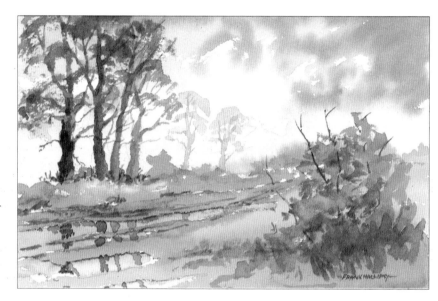

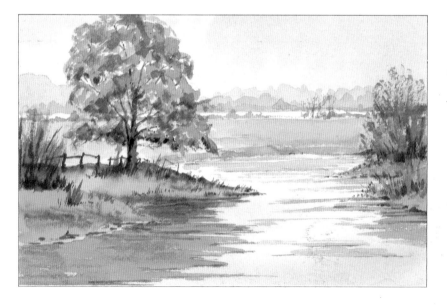

Slightly rippled water *The sky in this picture is simply stated – raw sienna was washed over the complete picture, then cobalt blue was worked over the top and up into the sky. The fields are varying mixes of the same colours. Cadmium yellow was used in the foreground tree and the bushes to add warmth. The ripples were indicated by horizontal lines across the lake, and the ripples reflect the sky colours.*

Waterfall This sky was washed in with raw sienna. A weak wash of French ultramarine and burnt umber was introduced close to the horizon then carried on into the left-hand bank and the water rushing over the rocks. The rocks were painted in a stronger mix of the same colours. I left areas of paper unpainted to represent the cascading water. The right-hand bush was washed in using French ultramarine and cadmium yellow, then the distant spindly trees were lightly painted in to complete the picture.

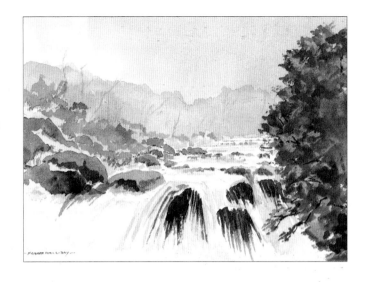

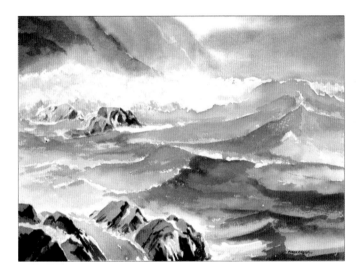

Rough sea The distant cliffs and foreground rocks were sketched in and the foaming waves were masked out. The sky was washed in with raw sienna and Winsor blue (red shade). Alizarin crimson was introduced from the top left-hand corner whilst the sky was still wet. The distant cliffs are the same colours; I varied the tones until I had almost lost the farthest one in the sea spray. I used Winsor blue (green shade) to create the translucent effect where the wave was just breaking. The foreground rocks are a mixture of raw sienna, burnt sienna and burnt umber. I left spaces over the rocks to show the water running over them from the previous waves. The swell of the sea was washed in with the two blues mentioned, and alizarin crimson was used in the shadowed area of the foam.

Estuary I began by masking out the gulls and the other areas I wanted to retain as white. The paper was then washed with a mix of cadmium yellow and a little Winsor red, then a few streaks of just Winsor red were introduced. The top section of the sky was painted with a weak mix of Payne's gray, and I allowed streaks to come down into the red. The same mix was swept into areas of the estuary. When dry, the distant hills were painted in with French ultramarine and a little alizarin crimson; again some of these colours were carried into the distant marsh. The greens of the marsh in the middle distance were worked in French ultramarine and raw sienna, and the mud was loosely applied with French ultramarine and burnt umber. The boats were painted in, the masking fluid was rubbed off, and finally, the ducks were painted in silhouette.

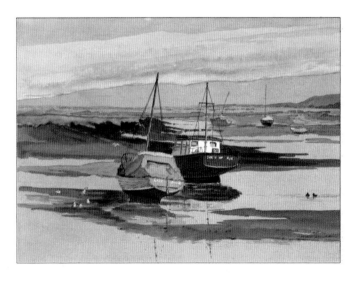

Quay at Low Tide

No landscape book would be complete without a project that includes sky, water and boats. I will take you through the painting step-by-step and I am sure that by this stage you will be able to paint a really super picture.

What you need

French ultramarine, burnt umber, alizarin crimson, raw sienna, Winsor red, Payne's gray

640gsm (300lb) Rough watercolour paper

No. 12 round brush

No. 3 rigger brush

4B pencil

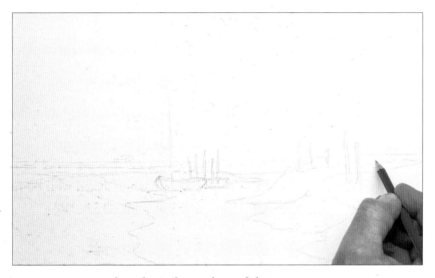

1. Use a 4B pencil to draw the outline of the quay.

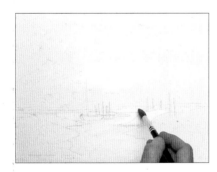

2. Use a No. 12 round brush to wash water into the centre of the sky area and into the centre of the estuary and the banks. Add raw sienna to these areas.

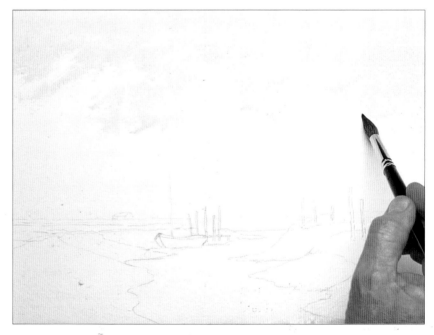

3. Mix up a wash of French ultramarine and use this to paint in the sky. Leave white areas for the clouds.

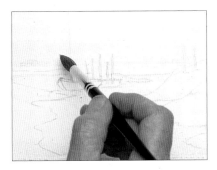

4. Weaken the strength of colour as you come towards the horizon. Add a touch of alizarin crimson to the horizon to add depth.

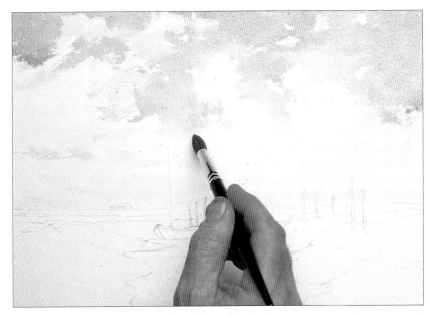

5. Paint in the dark clouds using French ultramarine mixed with burnt umber and a little alizarin crimson. Weaken the strength as you approach the horizon.

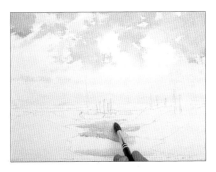

6. Reflect the colours of the sky in the estuary. Leave to dry.

7. Use the very tip of the brush to paint in the distant land and the boathouse with French ultramarine mixed with a little alizarin crimson. Leave to dry.

8. Use French ultramarine mixed with raw sienna for the areas of grass on the marshland. Leave to dry.

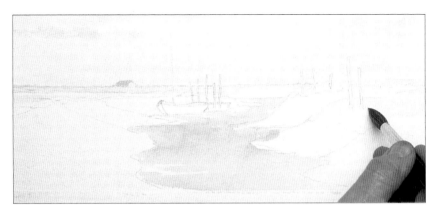

9. Strengthen the grass using darker tones of the same mix. Build up layers and darken the grass even further as you move forward. Try to keep the central area lighter.

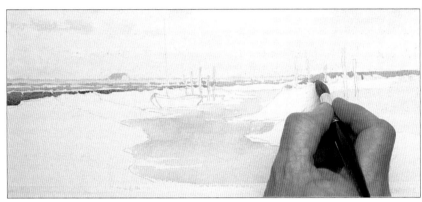

10. Use a light wash of burnt sienna with a touch of French ultramarine to build up the banks of the estuary.

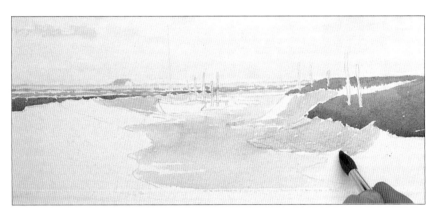

11. Use a stronger mix of the same colours to add shape and shadow to the bank, and detail to the foreground.

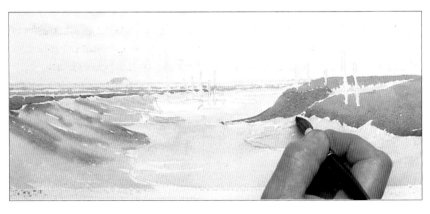

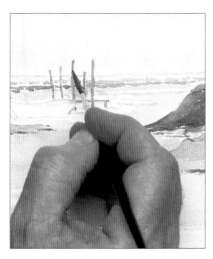

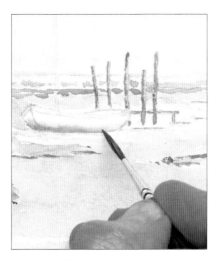

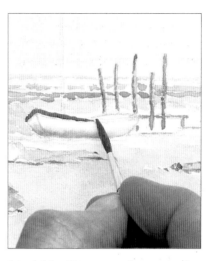

12. Use a No. 3 rigger brush and raw sienna to paint the mooring posts. Darken the shade to add shadow.

13. Use the same brush to paint the boat with water. Drop in Payne's gray at the bottom of the boat and allow it to merge with the water.

14. Add a Winsor red stripe along the side of the boat.

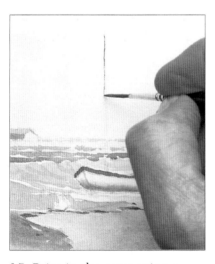

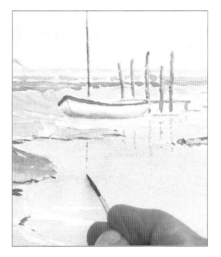

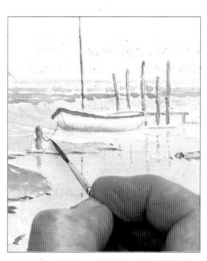

15. Paint in the mast using a strong mix of French ultramarine, burnt umber and a touch of alizarin crimson.

16. Add reflections of the posts and mast using a mix of raw sienna with a touch of burnt umber. Use weak Winsor red for a faint reflection of the boat's stripe.

Note *Darker colours reflect lighter in water, and lighter colours reflect darker.*

17. Add a mooring post using raw sienna with a touch of burnt umber. Paint in a reflection using a weaker shade of the same mix. Use raw umber, French ultramarine and alizarin crimson to paint the rope.

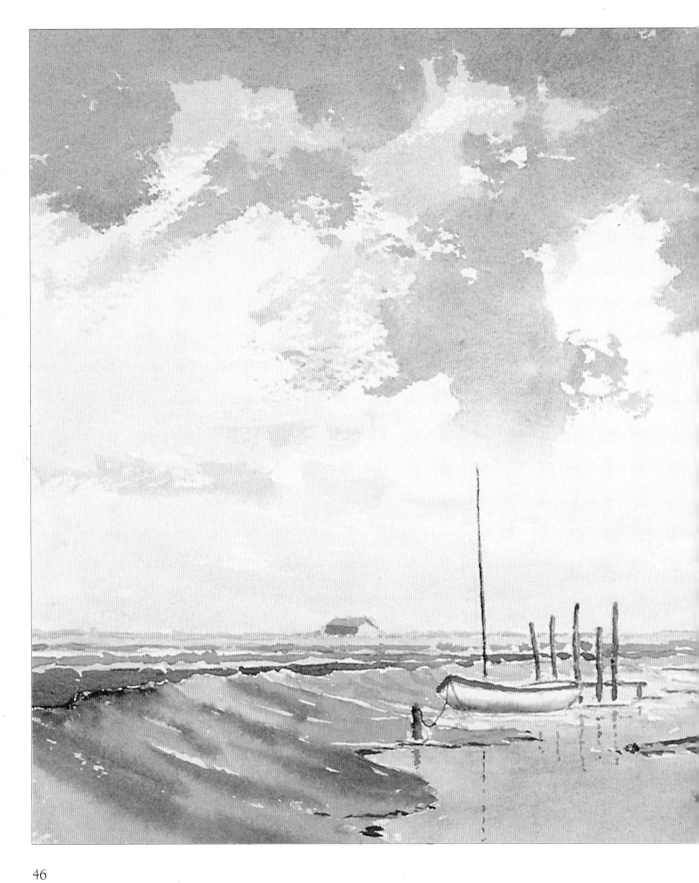

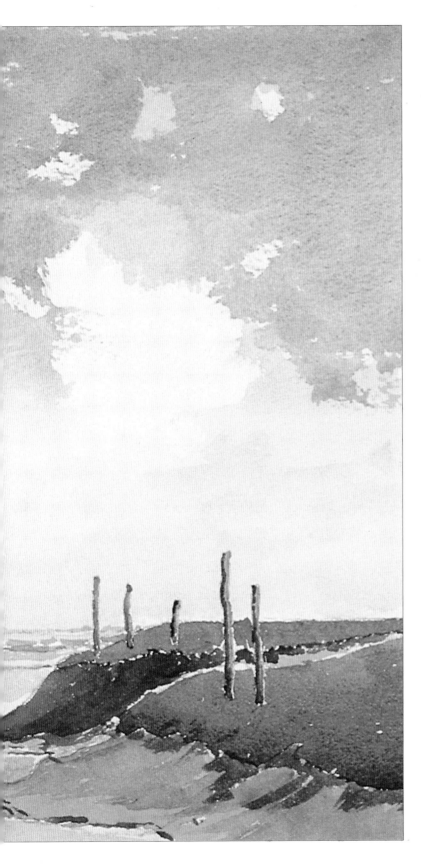

The finished painting
355 x 255mm (14 x 10in)

I saved this for the final demonstration as most of my students enjoy these kind of subjects – big skies, open country, space to breath and a lovely day. What more could you want!

Index

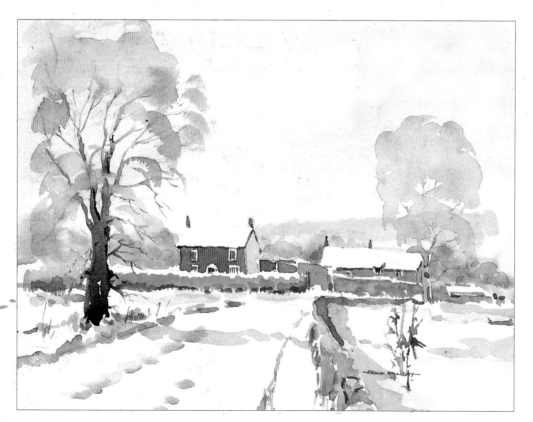

Sudden Snow
255 x 205mm (10 x 8in)